In working with Michael Pollock at The Second City, I have seen him transform the most terrified of students into singing improvisers in a matter of minutes. He does for musical improv what Stephen Hawking did for quantum mechanics — take an intimidating subject and break it down for the rest of us.

Michael Ross
Director and Teacher of Improvisation

Reading this book is seriously just like being in class with Michael. This is the bible of basic musical improvisation. The CD is an indispensable learning aid, and it makes driving in L.A. traffic more bearable.

Freddie Sulit, *student*

Michael's style is light and fun, yet tremendously informative. Between the book and the CD, he is simply giving it away—all the tricks, terminology and techniques you need to sound like you've been doing this for years.

David Karson, *student*

Michael has always been like a textbook of how to improvise music, so I guess it's about time he wrote one. He sure makes it sound easy, and with his help it almost is! Anyone who is going to improvise songs and such should pick up this portable Michael Pollock.

Frank Maciel
Show Director, Disneyland Resort

Nothing makes up for actually taking a class with Michael, but this is the next best thing. I actually hope that people don't buy this book, because I don't want everyone to be able to do this, and if you read the book, you will.

Gary Warren, *student*

This book explores the subject in a way that anyone can understand. It gives you all the tools and musical tricks you need, so that you really can create original songs right off the top of your head.

Stephanie Sheh, *student*

This book is full of tools and techniques that de-mystify musical improv. Michael makes every step clear, concise and a lot of fun. I have taken his class and recommended it to my own students. Every actor or singer should get a taste of this kind of creativity.

Evelyn Halus
Vocal coach Oscar, Tony and Grammy winners; B'way productions of *Rent, Hairspray, Thoroughly Modern Millie, Grease, The Producers...*)

Michael goes into a kind of depth that I'd never experienced in studying musical improv. With no prior musical training, many of us learned to be instant songwriters.

Bruce Tenenbaum, *student*

Michael Pollock taught me how to construct improvised songs that sound like tunes people have been singing for decades. His methods are easy to understand and simple to implement. Studying with him has given me the confidence that comes with firsthand knowledge.

Michael Konik, *student*

I adore Michael Pollock! He is an amazing teacher and artist who is kind enough to have shared his knowledge and passion with improvisers and singers everywhere.

Amy Seeley
*Improv instructor and founder of
The Factory Theater Company, Chicago*

Who would have thought that musical improv is as much a science as an art? This book is an amazing recipe and a must for any member of an improv troupe."

Duane Dike
Disney Entertainment Productions

Musical Improv Comedy
Creating Songs in the Moment

By Michael Pollock

ISBN 0-9747427-3-2

Published by:
Masteryear Publishing
1607 N. El Centro Ave #6
Hollywood, CA 90028 U.S.A.

Editor: Sonja Alarr
Cover design, illustration and layout: Michael Sherman
Cover photo: © Michael Pole/ CORBIS
Musical graphics: Thomas Griep, The Enchanted Cottage, Los Angeles CA

Instructional CD recorded at Grandma's Warehouse, Los Angeles CA
Engineered by Ted Scarlett
Mixed and mastered by William Cooke, Raven Mastering, Chatsworth CA
Vocalists: Shulie Cowen, Sami Klein, Norm Thoeming, Jack Voorhies
Piano: Michael Pollock

Library of Congress Control Number: 2003115516
Pollock, Michael
Musical Improv Comedy: Creating Songs in the Moment / by Michael Pollock

MUSICAL IMPROV COMEDY

Creating Songs in the Moment

by Michael Pollock

MASTERYEAR
PUBLISHING
Hollywood, California

TABLE OF CONTENTS

CD Tracking Information

The actors on the CD have quite distinctive voices. As you listen to the examples you'll come to recognize each individual as he or she comes and goes from the recording. I want you to know who's who among these wonderful improvisers, so here's some info to clue you in: Jack Voorhies first appears on tracks 2-4, Sami Klein on track 7, Shulie Cowen on track 9, and Norm Thoeming in the 4th example on track 10 ("Barstow is a lonely town").

Foreword

By Jason Alexander

I would like to proffer the following definitions.

Improvisation: the spontaneous creation of comedic or dramatic performance based upon a suggested premise. Impossible: doing the preceding with music and lyrics.

And yet, I have seen the impossible done over and over in comedy clubs, theaters and other performing venues as improv performers create complete songs in music and lyric based on a premise heard only moments before. I have always considered it one of those sort of "idiot-savant" abilities that people with extreme mental or personality impairments have. Mere mortals could never do it. And why? Because no one could possibly teach this skill. Therefore, if it cannot be learned, it must be innate and you either got it or you don't. Right? Wrong!

In this book, Michael Pollock will take you through a detailed, precise methodology to develop the skills required to do exactly what I've described. I have watched Michael and his prodigies do it time and time again. He is perhaps the only teacher I am aware of that is capable of conveying the approaches, the challenges and the solutions to this unique art. Indeed, this slim volume will tell you everything you might ever need to know to start creating original, spontaneous musicals out of gossamer ideas.

Additionally, Michael has provided an invaluable tool. The accompanying CD will allow you to practice your skills alongside a gifted musician. The person at the keyboard is equally vital as the person singing. But, unless Michael is a friend of yours, it is rare to have someone who can lay down the musical structures from which you can rehearse.

This complete program approximates all the elements of live performing of musical improvisation in an actual environment. Use it well, let it educate and excite you, free your imagination and your transition to actual performing will be seamless.

Had I not seen it done with my own eyes, I wouldn't believe it myself. I have seen it. I do believe it. The results are magical. And as is so often true, it is even more fun being the magician than the bedazzled audience.

So, warm up your vocal cords, limber up your imagination and spring forward into the amazing world of the impossible: musical comedy improvisation with the master, Michael Pollock.

Introduction

Above the Line, Below the Line

*The difficult becomes habit, the habit becomes easy,
the easy becomes beautiful*

It's great to perform a spontaneous song and feel the appreciation of an audience that can hardly believe you "just made that up." As you work with the contents of this book, you may be surprised at how easy it is.

For our purposes, "above the line," means that a song sounds like a professional product. Many factors will come into play, and the more times you hit the nail on the head, the more your song will seem astonishingly like some well known, published composition. You don't have to be a gifted vocalist. I know many terrific musical improvisers who don't really sing that well, but they've mastered a variety of ways to commit to a musical performance which make them a treat for all to see and hear. "Below the line" means rougher, more home-made. This is fantastic for cookies.

I'm going to present a great many technique-builders which will serve you well when you're on the high-wire, thrilling the crowd.

Just like acquiring muscles at a gym, then going about your life able to open difficult jars with ease, you can become a musical-improv athlete. Work out and get strong—then when you "play," you just play. Extremely well. Everyone will love and admire you; won't that be cool?

You may already have some combo of talent and experience that makes musical improvisation a snap. In that event, this book can still be useful for you—it's great to address basics, as they tend to elevate the work of even the most skilled artist. One of my teachers, Dick Grove, said *"Craft liberates genius."* This statement has rung in my ears for a long time and has inspired me to continue pursuing exercises which strengthen technique and result in better freestyle creativity.

If you're a beginner who is willing to experiment patiently with the information that follows, an enormous amount of sure progress awaits you. I've done my best to make everything clear and do-able, even though your musical background may be limited.

I suspect that most readers will have previous or concurrent experience with comedy improv in general. If this book is your very first exposure to improv, I hope it leads to a lifelong exploration of the art form from all angles. Singing is a joyful way to start. Above-the-line, here you come.

1

That Reminds Me of a Song

Getting and working with suggestions from the audience

You need something to sing about, something to launch a song. The audience is going to give it to you. Here are some ways to get suggestions from them:

1. What's the title of a song that doesn't exist?

2. What's a word that begins with the letter T (any letter)?

3. What's the last thing you bought at a convenience store?

4. What's the nicest thing anyone's ever said to you?

5. Can I have an adjective? And a noun? (Put them together for a song title.)

6. How about some advice your mother gave you?

7. Give us a natural phenomenon, like rain, or the Grand Canyon.

8. What's something that drives you crazy?

9. What costs more than $50 and less than $100?

10. Where do you go when you're in love?

Sometimes the audience response is funny in itself:

Q: "Where do you go when you're in love?"
A: "Michigan!"

The audience provides subject matter (*"Dolphins!"*)...what will you do with it? The unexpected. This is part of the magic trick that is musical improv. You're going to create an illusion of sorts.

"Ladies and gentlemen, I propose to take this ordinary suggestion, and before your very eyes..."

You will craft a song in the air where none existed before. People love a good song and they love to be the catalyst for your brilliance. We're going to take "dolphins," divine melody, rhyme and rhythm in the moment, and make a hero of the person who suggested it. An audience member becomes the proud owner of a suggestion when we use it in a great way.

The best way to create a meaningful song is to put a relationship at its center. Tina Turner asks: "What's love got to do with it?" Absolutely everything. A love song isn't the only kind of song

there is; you could go on and on about the wonders of the Good Ship Lollipop or the deliciousness of being the Grinch—sometimes that's appropriate.

Meanwhile, you can never go wrong singing about love.

Of the two examples below, which is more compelling?

a. *Dolphins are so beautiful*
What a wonderful thing to be
They seem to smile at each other
As they play in the briny sea

Dolphins, lovely dolphins
Frolicking in the sun
Sleek and shiny and graceful
You can tell they're having fun

This fills the bill for a children's song, if that happens to be a requirement. It's fine and the suggestion is used well. If, however, your options are wide open, better to go for what really interests us...passion.

b. *The days were long without you*
I'd sit and stare at the tide
I didn't care for the sunset
Without you by my side

I never thought I'd see you again
I thought you'd found another
Or were we two dolphins lost in the waves
Trying to find each other?

The Dolphin Song is now brimming with emotion. The suggestion "dolphins" itself became a metaphor for the two lovers. Also we saved it for awhile, so that its inclusion was a surprise. While it's perfectly okay to quote the suggestion right upfront, delay works well.

Are these lyrics funny? Not so much, but the audience is giggling and grinning already at the miracle of an instant-song to which you're absolutely committed, tongue firmly in-cheek. You'll see as we progress that you need never worry about "jokes." Let your wit emerge where it may, and concentrate always on the objective of creating a song based upon the audience suggestion which sounds like a standard we've all known for years. If you can do that, the laughs will come, believe me.

Experiment with using the audience suggestion as a springboard to lyrics that aren't literally about the suggestion itself.* Instead, make it the poetic inspiration which connects to a high-stakes life experience—a tale of love or the pursuit of a dream. Painting a sentimental, emotional picture is an excellent way to imitate the most popular songs ever written.

So...the piano player plays, and we're off. If you can begin singing in 5 seconds or less, perfect. Immediacy makes a magical impression. One way or another, you must go into action. As the introduction establishes a musical environment, you can say nothing, "filling the moment" as an actor; you can move to the music; you can pull up a stool...

*I think it was improviser Joe Whyte who once observed that any suggestion can be the name of a pub: "Hey, anyone heading over to the Dolphin tonight?" This is very cheap, and I like it very much.

It works beautifully to chat as the piano intro continues. If you're working with another actor, a little dialogue between you before anyone sings is a great way to show the audience your relationship.

PATTER

In the context of a concert or club act, talking before, during or after a song is called "patter." So is the spoken routine that a magician uses when presenting an effect. Songs that are more spoken than sung are known as "patter songs" in the theatre.

The intro is happening, you're acting, you're moving, you're sitting, you're chatting ("This was my dear mother's favorite song.") and finally you're about to sing. On to Chapter 2.

2

When Do I Come In?

The instrumental introduction

THE OFFER

In the world of improv we're always talking about offers and acceptances. When someone makes a statement of any kind, it's "an offer." The thing to do is accept it by agreeing that it's true. To do otherwise is to "deny."

Example:

>Offer: "I'm so glad we came to the beach today, so we could be alone together."

>Acceptance: "Me, too. It's been too long since we got off by ourselves in the salt air. I brought your favorite suntan lotion."

Denial: "Could you move Grandma over?
I've got to get these brownies out of
the oven."

You get the idea. Go with what's been offered, not against it.

An instrumental introduction to a song is a *musical offer*. There
are a few different kinds of intros I want to tell you about:

THE VAMP

A vamp is a musical cycle that repeats over and over. It keeps
going until you sing.

A vamp presents useful information—it establishes a "key" for the
song (a place in your vocal range where you'll sing), tells you how
the song feels and how quickly or slowly it moves.

You will be able to count an easygoing "1-2-3-4" with the sound
of any vamp. Your body will be inclined to move to the music.
Listen to 4 different vamps on **CD track 1**.

Once you hear how a particular vamp goes, it's easy to predict
when it will "loop" back to the beginning. Listen to the following
recorded examples—they demonstrate 3 simple ways you can
begin singing. **Bold** represents beat 1.

a. **Track 2**: Entrance prior to "1"
*Play **me** an intro, Mike
The kind you know I like*

b. **Track 3**: Entrance right on "1"

Play me an intro, Mike
The kind you know I like

c. **Track 4**: Entrance after "1"

(one) Play me an intro, Mike
The kind you know I like

The good news: You can usually get away with jumping in any-where during a vamp. An artful accompanist will cover an odd vocal entrance in such a way that no one will ever know it hap-pened. Relax.

THE COMPOSITIONAL INTRO (track 5)

This is a melody that plays for awhile, sets the key and the mood of the song, then stops and waits for you to sing.

It should not stop until you're *ready* to sing, so it's up to you to let your accompanist know when that is ("...and it goes something—like this"). At that point the intro should come gracefully to an end.

You can sing right away or pause dramatically. The silence is all yours.

A COMPOSITIONAL INTRO FOLLOWED BY A VAMP (track 6)

As you can tell from the title, this intro is a melody that plays for awhile, then goes right into a vamp.

∽↜↝

There you have them, the best approaches to working with intros of improvisational songs. On some occasions a musical style may dictate something else, like a lone bass line or a drum pattern accompanied by a bass line. These intros are easy to enter vocally whenever the spirit moves you. Try listening for "1" and sing just as if you were hearing a vamp.

3

Car, Far, Star, Bar, Tar

How to create rhyming lyrics

Rhyming is an essential skill in musical improv. The songs we know and love commonly rhyme in some way, so this is a factor that makes a song sound "real." Professionally written songs usually rhyme in an identifiable pattern, called a rhyme scheme. Here's an example of an "ABCB" rhyme scheme:

There's nothing like a pizza	A	begins the "lyric story"
*When I'm feeling **blue***	B	sets up a rhyme
The smell of pepperoni	C	continues the story
*Always makes me think of **you***	B	fulfills the rhyme

Line "A" above ends with **pizza.**
We call the next line "B" because **blue** does not rhyme with **pizza.**
The next line is "C" because **pepperoni** rhymes with neither **blue** nor **pizza.**

The last line is called "B" again because **you** rhymes with **blue**.

Get it? Let's do it again:

Your lips were sweet red peppers	A
*Touched with **anchovies***	B
Our love was hot and tasty	C
*It was large with extra **cheese***	B

Now you fill in the blanks:

You were my Italian feast	A
All mine to drink and _____	B
You were my tomato	C
Juicy, plump and _____	B

Luigi's doesn't feel the same	A
Since we said _____	B
Over glasses of Chianti	C
And bubbly pizza _____	B

Rhyming is a mental muscle that you can develop with practice, and the ABCB pattern is a nice exercise because it requires you to rhyme only once during 4 lines.

Compare it to these other common rhyme schemes:

1. *The snow was gently **falling***	A
*When I considered **calling***	A
*But in my heart I **knew***	B
*I had no chance with **you***	B

2. *I love to play* **piano** A
 All night **long** B
 Will you be my **soprano** A
 And sing a moonlit **song?** B

3. *When this song is* **done** A
 I really have to **run** A
 It's been a lot of **fun** A
 See ya later **honeybun** A

Songs can rhyme in a variety of ways. Experienced improvisers will throw in rhymes all over the place, or emulate sophisticated schemes that come easily to them. If you can do that, go for it!

Here's the thing—if you need a procedure to begin making up lyrics that rhyme, I highly recommend the ABCB approach. It's simple and perfectly legitimate; a lot of famous songs go just that way.*

Don't worry about being too clever; just practice building the pattern based upon any subject: hotels, girls, gardening...anything you can talk about, you can sing about. The element of "surprise lyrics" that happen when you fulfill rhymes will frequently be funny even though you were simply trying to rhyme.

In my classes at The Second City Los Angeles Training Center, we begin by doing one line per person, and we don't try to keep a beat going—just construct words. We don't even sing at first. And the subject is...rain!

*To name a few: Let It Be, Piano Man, The Brady Bunch Theme.

Jimmy: *The rain was falling down.*

Susie: *I got out my **umbrella***

Bobby: *And took a walk down the block*

Debbie: *And wished I had a **fella***

It's possible to do a lousy rhyme set-up (*orange*—the cruel fruit). The very easiest ones tend to end with open vowels but any common word-ending is good.

The classroom process of creating lyrics goes on haltingly for awhile as everyone catches on. Very soon we're able to keep up with a regular cycle of beats, with a simple piano accompaniment carrying the flow along, like a song!

An improvised song need not feature a consistent rhyme scheme in order to be successful. Every time you do rhyme, the audience will love it; however, they often won't notice when you do not, as long as the song holds together in other ways.

We're working on being "songlike" here, and this is only one aspect of that effect. It's the combination of multiple, contributing elements that deliver a dazzling product.

Recommended reading:
The Hip Hop Rhyming Dictionary for Rappers, DJs and MCs by Kevin M. Mitchell

RHYMING PRACTICE GAME

Play this with 2 or more actors. The goal is to get better and faster at rhyming; the more players, the merrier.

Pick a one-syllable name (like "Bob") and work with it as follows:

First person:
> *I know a guy whose name is Bob*
> *He just got a brand new **job***
> *That's what I know about a guy named Bob*

Second person:
> *I know a guy whose name is Bob*
> *He's got a watch with a shiny **fob***
> *That's what I know about a guy named Bob*

...and so on. Take turns as long as you can keep rhyming, then get a new name and start again. You can make just one rhyming line, as above, or insert as many as possible before wrapping up the verse:

> *I know a guy whose name is Bob*
> *He looks great, he ain't no **slob***
> *His favorite food is **corn-on-the-cob***
> *Dripping with butter by the **gob***
> *That's what I know about a guy named Bob*

Give 2-syllable names a try:

> *I know a girl whose name is Gina*
> *Never stands up straight, she's a **"lean-ah"***
> *She's petite like **Thumbelina***
> *That's what I know about a girl named Gina*

This is also easy to do by yourself for a few minutes each day. Soon you will develop quite a collection of rhymes that come easily to mind. This exercise will prepare you to play the "Competition Rap" game described in Chapter 10.

4

Feeling the Groove

Improvising in rhythm

The origin of both "rhyme" and "rhythm" is the Greek word, "rhymus," meaning "flow." A rhyme creates a pleasing flow of words. Rhythm is a flow of sound across time.

Musical improv is exciting because audiences know that a song can literally "go on without you" if you don't keep up with the beat. It's really impressive to see improvisers think fast enough to maintain musical flow.

TEMPO

Tempo means "time." When music moves along in such a way that you are influenced to react physically—like tapping your foot, swaying back and forth, moving your head to the beat, anything like that—it's because the sound is flowing in a very predictable way.

Your natural body movement will express "1-2-3-4" in some way, as we talked about in Chapter 2. This is "being in tempo." When there is no regular series of beats apparent, we call it "out of tempo" or "freely."

(**Note to musicians**: I'm not talking about any particular "time signature" like 4/4, 6/8, 3/4 or the like. For example, in a waltz we'll hear measures or groups of measures passing in sections that will suggest a way to count "1-2-3-4" at some speed.)

There are endless ways that lyrics and melody can move across time over accompaniment. A slow accompaniment doesn't necessarily demand "slow singing," nor does a fast tempo demand that you spit out a song at breakneck speed. It's very much up to you (and easy) once you understand the options.

Listen to these examples:

	Accompaniment	Lyrics/Melody
Track 7:	a. Slow	Slow
	b. Slow	Medium
	c. Slow	Fast
Track 8:	a. Medium	Slow
	b. Medium	Medium
	c. Medium	Fast
Track 9:	a. Fast	Slow
	b. Fast	Medium
	c. Fast	Fast

Beginning students ask me how long one line of a song should be. "One line" of lyrics can fit into any span of time that feels good to you—just think of it as 25% of a four-line section. A little practice working with different tempos will help you develop a good sense of this.

5

Same Song, Second Verse

The building blocks of a solid song

Popular songs are modular. They will contain a section, followed by a section, followed by a section. Because you've been hearing music for many years, you're bound to be aware of this in some way. If a song *isn't* organized in a certain agreeable fashion, you'll notice that something seems out of joint.

Songs are commercially made to be heard and remembered. One of the ways this is accomplished is by sturdy construction. You can certainly create a song that is wild, meandering and unpredictable. It may be beautiful and people will enjoy it; however, they will be unlikely to hum it on the way out.

Oliver Wendell Holmes said, *"For the simplicity that precedes complexity, I wouldn't give a nickel. For the simplicity that comes after it, I would give my life."*

Oh, and Dick Grove, my teacher, was fond of saying: *"The longer your song, the greater will be its tendency to suck."* He refers to the composition that gets out of hand, wandering aimlessly. We're not worried about that because we're deeply committed to imitating the masters in all ways.

THE VERSE

A verse begins and advances the lyric story of a song. It's usually 4 lines long, and has a rhyme scheme.

Let's take a look at a song that most people know, "Rudolph, the Red-Nosed Reindeer."

Verse 1: *Rudolph, the Red-Nosed Reindeer*
 Had a very shiny nose,
 And if you ever saw it,
 You would even say it glows.

Verse 2: *All of the other reindeer*
 Used to laugh and call him names,
 They never let poor Rudolph
 Join in any reindeer games.

These verses have similar melodies and in both verses the lyrics move with the melody in exactly the same way. We may not always achieve that when improvising, but shooting for perfection is a good thing.

The *resemblance* between these two verses is the reason we perceive that this is one verse followed by another. Otherwise it would seem like a verse followed by something else entirely.

THE BRIDGE

A bridge is typically the third section in a song containing four sections. It provides musical variation for the listener – a break from the verse melody. It's commonly the same length as a verse.

Look at the bridge of "Rudolph, the Red-Nosed Reindeer:"

> *Then one foggy Christmas Eve,*
> *Santa came to say,*
> *"Rudolph, with your nose so bright,*
> *Won't you guide my sleigh tonight?"*

It has 4 lines, same as a verse. The melody is different.

It also has a different rhyme scheme than the preceding sections. The verses are ABCB and the bridge is ABCC. That's one more way to make a bridge vary from everything else.

Now for the final section of the song:

Verse 3: *Then how the reindeer loved him*
 As they shouted out with glee:
 "Rudolph, the Red-Nosed Reindeer,
 You'll go down in history!"

The final verse is musically similar to the first two. And that's the whole thing. The song goes "verse-verse-bridge-verse."

Now let's observe this form in a completely different kind of song, "Remember Tonight and Smile."

Verse 1:	Don't care if I ever have a dime
	If I can keep you rolling in the aisle
	In your book of memo**ries**, keep this melo**dy**
	Remember tonight and smile

Verse 2:	Even when the road's a little rough
	Your laughter keeps me traveling in style
	Keep me in your **heart** even as we **part**
	Remember tonight and smile

Bridge:	Give me the stage and I'll give you the one-two-three (the premise, the setup, the punch!)
	The love of my life is a
	lady named "comedy"

Verse 3:	Here's hoping your tomorrow is grand
	It's been great to entertain you for awhile
	Here's a thought to see you **home**, and wherever you may **roam**
	Remember tonight and smile*

This song goes verse-verse-bridge-verse, the same modular form as "Rudolph the Red-Nosed Reindeer."

The rhymes are all ABCB, with the addition of an "internal rhyme" in line C of each verse, shown in bold.

*I wrote this for the film, *Punchline*. My assignment was to create a schmaltzy song for an elderly comic to sing at the end of his act. They only used the first and last verse—one near the beginning of the movie and the other at the fade-to-black. To my dismay, the actor never managed to learn the words; he sings "Remember this night and smile." Dang.

THE CHORUS

A chorus is the part of a song with which we ("the chorus") all sing along. It occurs at least twice, maybe even 3 or 4 times. Why do we join in so eagerly to sing it? Because it's simple and memorable, and it comes around again and again. The lyrics always sum up the overall point of the song.

Not all songs feature a chorus. Upbeat pop songs usually do, and frequently they *start* with at least part of the chorus in order to start drilling you right upfront in how it goes. The following example does that very thing, in a Motown hit, "Baby, I Need Your Loving."

The song begins:
> *Baby, I need your loving*
> *Baby, I need your loving*

Okay, we got that. Later it will become:

> *Baby I need your loving*
> *Got to have all your loving*
> *Baby I need your loving*
> *Got to have all your loving*

We will hear this come around several times during the song, and finally at the end we'll hear it over and over, fading out. Notice that it's extremely simple, and occupies 4 lines.

The lyrics above would work perfectly in a musical-improv setting.

Here's a good procedure for creating a chorus:

1. *One* singer should create 2 lines that reflect the overall sub-
 ject of the song. They can be identical, but don't have to
 be. Keep them simple. They don't have to rhyme.

2. *Repeat* these exactly, creating a complete cycle of 4 lines.

The first 2 lines of your chorus will demonstrate how-it-goes, to
the audience and perhaps to fellow improvisers. Then it's time for
them to sing along.

They may not be certain it's a chorus until you begin *repeating* the
2 lines, but they'll catch on, especially if these first 2 lines sound
really chorus-like to begin with—simple and sum-uppy.

Later in the song, like after another verse or 2, you'll introduce
this chorus again. We already know it, so we'll join in and sing
along. The key to creating a successful chorus is making it simple
enough to remember.

Here are examples of some easily-duplicable offers for choruses
(CD track 10):

> a. *Let's take a vacation*
> *Oh Lord, we need a vacation*
>
> b. *I love fishing*
> *And fishing loves me*
>
> c. *I can't get you out of my heart*
> *I can't get you out of my heart*

d. *Barstow is a lonely town*
A lonely, lonely town

The choruses of well known songs may sometimes contain more interesting variation than the ones we improvise, but this is the best way to do it on-the-fly and in the moment.

THE TAG

A tag consists of a few "extra" lines of lyric and melody that become part of the end of a song. Its purpose is to provide surprise variation, making the last section more interesting.

Here are the lyrics of the last verse of "Remember Tonight and Smile" again, this time with the addition of a tag:

> *Here's hoping your tomorrow is grand*
> *It's been great to entertain you for awhile*
> *Here's a thought to see you home, and wherever*
> *you may roam*
> *Remember tonight and smile.*
>
> **You can't go wrong**
> **If you leave 'em with a song**
> **They'll remember tonight and smile**
> **Remember tonight and smile**

Tags are very useful when you want to build a creative ending. They're particularly easy to do in a solo, when only you and your accompanist are involved. Chapter 7 is all about endings, so more on that subject later.

LABELING SONG FORMS

Just so you know, we can define the forms of songs with letters. Please breeze lightly over this information as it threatens to become tedious.

All that's important is that verses, choruses and bridges can fit together in various ways.

AAB
verse-verse-chorus
Let It Be
Stand By Your Man
Delta Dawn
Leaving on a Jet Plane

AABA
verse-verse-bridge-verse
Cabaret
The Christmas Song (Chestnuts Roasting on an Open Fire)
When You Wish Upon a Star
Over the Rainbow
The Shoop Shoop Song (It's in His Kiss)
You Go to my Head
Georgia
Yesterday

AB
verse-chorus
Jingle Bells (long chorus, basically doubled)
Yankee Doodle
Friendship (by Cole Porter)

AABC
verse-verse-bridge-chorus
Faith
Downtown
Crocodile Rock

AA
verse-verse
Summertime
On Top of Old Smoky
White Christmas
Puff the Magic Dragon

When you listen to songs you'll hear numerous creative choices that writers and singers have made with the "building blocks." Try to identify what's going on—notice what seems to be a verse, a bridge, a chorus, a tag. It won't take you long to get good at this, and will add greatly to your musical know-how.

RHYMING TIP

Pick any two words that rhyme and create a mental picture that links them, which you can then translate into rhyming lines.*

Example: wish / fish

I sat on a rock in the noonday sun
And made a secret wish
More than anything in the world
I'd love to be a fish

Example: hill / still

Up and up and up we trudged
On to the top of the hill
Finally we found it
Daddy's moonshine still

*My thanks to improviser Dave Cox for this useful hint.

6

Get the Hook

The songs we can't forget

"Theme, Thematic, Thematicism." These terms refer to anything that becomes memorable as a result of repetition. It doesn't have to be brilliant; it just has to happen more than once. Or even more effectively: again and again and again and again.

A *hook* is a portion of a song that sticks in the brain. It's called a hook because it grabs our ears and holds on. It can be melodic or lyrical or both—whatever we're hearing over and over. When you think of a song that you can only remember a little bit of, the hook is likely to be in there. It's "catchy" because it catches your attention.

Listen mentally to the melodies these titles may bring to mind. You may not know all of them, but 90% is a pretty sure thing:

1. Feelings

2. Take Me Out to the Ballgame

3. Ob-la-di, Ob-la-da

4. Like a Virgin

5. You Make Me Feel (Like a Natural Woman)

6. Mister Bojangles

7. Frosty the Snowman

8. How Sweet It Is (To be Loved by You)

9. Desperado

10. Gypsies, Tramps and Thieves

When you think of these songs, the very first thing you hear in your mind is probably the hook. (Sometimes it's in the chorus, sometimes it's in the beginning or end of a verse. It's whatever repeats memorably.) You probably associate many songs with a tasty bass line, a signature intro, a trumpet lick that recurs. All of these can be statements of a hook.

We hear a classic song so many times in our lives, it's almost as though the whole damn thing becomes a hook. But a song becomes successful in the first place because of that one musical confection no one can seem to forget.

THE "TAGLINE"

Think of a "tagline" as a statement that the whole song is about, and save it for the last part of all your verses.

A great many standards are tagline songs:

1. *Start spreading the news*
 I'm leaving today
 I want to be a part of it
 New York, New York

 These vagabond shoes
 Are longing to stray
 Right through the very heart of it
 New York, New York

2. *What good is sitting alone in your room?*
 Come hear the music play
 Life is a cabaret, old chum,
 Come to the cabaret

 Put down the knitting, the book and the broom
 Time for a holiday
 Life is a cabaret, old chum,
 Come to the cabaret

*My fellow keyboardist, Travis Ploeger, uses this device extensively in his work with musical improv. Our discussions inspired me to include it here.

Here's an example of a tagline holding down the fort in verses that don't rhyme at all:

> *The ways you always make me smile*
> *The treats you bring my dog*
> *The tabs you pick up when I'm broke*
> ***Make you a true-blue friend***
>
> *The times we crack each other up*
> *The times you just stop by*
> *The nights you don't let me drive drunk*
> ***Make you a true-blue friend***

It's a rare song that contains zero rhymes but you can get away with it if other musical elements are intact.

Thematicism is more than the hook, it's a multi-layered event. It's "one thing having to do with another," all over the place.

Consistency of verse melodies, a repetitive chorus (there is no other kind, right?), a possible tagline, multiple lyrical references to the audience suggestion—all these are thematic elements.

We incorporate thematicism into improvised songs not because we hope to sell a million CDs, but to emulate the standards everyone knows.

7

The Choo-Choo Train Theory

How to create terrific endings

Imagine a train coming into the station—the engine is pulling a lot of cars, a lot of weight. It takes awhile for the train to come to a halt; it has to "start stopping" a certain amount of time before it actually does. This is analogous to the ending of a song. In order to bring a song comfortably and satisfyingly to a close, we need to do it gradually.

The longer the song, the longer the ending should be. A quick song can end quite abruptly and the audience doesn't mind, as in a short children's ditty like "London Bridge is Falling Down." It starts, it continues, it stops, it's over, no one gets hurt.

When a song has gone on for two or three minutes, it's another matter entirely. We must design some kind of extended-conclusion, transporting the listener happily home.

Leading the way to this conclusion takes the form of a very committed musical offer, so that another improviser can easily join in. There's no room for subtlety here—use your voice and your body to show your intention.

Let's say you're trying to get a bunch of people to sing "Happy Birthday" in unison with you, and they can see and hear, but not all that well. Plus they don't know the song…you need to sing clearly and assertively, and perhaps help the process along by emphasizing things physically as you go. That's the kind of can't-miss-it offer I'm talking about.

Listen to **CD tracks 11-15** as we apply different endings to the verse below:

> *The eggnog flowed in Tinseltown*
> *Ev'ryone was there*
> *The Hollywood Christmas party was a*
> *Star-studded affair*

1. Repeat the last 2 lines of the song and *stretch out* the final line of the whole thing. This is a double-ending with the last line extended.

Track 11
a. You can stay in tempo all the way to the end, or

Track 12
b. ritard (see box below) on the last line.

Gradually slowing down a tempo is called "a ritard" (ri-TAHRD). It's short for "ritardando," meaning "slower." This word is often used as a verb: "Let's ritard the final line of the song."

Making a ritard happen in an improvised song requires someone—anyone—to make an assertive offer, going against the tide of tempo.

When you stay in-tempo all the way to the end of a song, there will be a final beat that is called a "button." Listen for this in the above example on **track 11**—it's the very last thing played on the piano, and sounds like you might strike a pose at that moment. And you really should. Do it.

2. Sing the last 2 lines *three* times and stretch out the final line of the whole thing. This is a triple-ending with the last line extended.

Track 13
> a. You can stay in tempo all the way to the end, or

Track 14
> b. ritard on the final line.

A triple ending puts the brakes on very gradually, making it clear to everyone (including the audience) that this is indeed the end of the song.

3. Sing the last 2 lines three times, period.

Track 15

 a. Stay in tempo all the way to the end.

This is a matter of going for a triple ending and seeing if it works out. If no one steps in with a new offer (like a ritard), it will feel good to wrap up the song "on a button." Hit that pose.

4. Do a "booth fade."

The control room of a recording studio is sometimes called "the booth." When someone decides that last portion of a song should fade away gradually to nothing, that's a post-production process, actually created in the booth. (Just as you suspected, the performers do not sing/play more and more softly until silence reigns.)

But we do! Together with a slow blackout, it's funny. Once in awhile we can treat the end of a song this way; it's a matter of someone onstage making an offer while something is repeating musically—like a chorus cycling over and over.

You want your fellow players to catch the drift as clearly as possible. As always, show the intention with both your voice and your body. As the song gets softer and softer, the lights slowly fade to black, the audience gets the idea and applauds. That's a booth fade.

Pre-inform the light operator of this possibility.

5. Build-up to a single sustain (held note).

When a song is grooving along in tempo, the end is nigh and we're repeating something over and over with no ending-offer in sight, do this: Take the initiative to hold a last note on the final word of a repeating cycle, and don't let go. Insist upon it.

Others will come along as soon as they realize what you're doing. Here's a lyrical example:

> *I want you to be my baby*
> *Want you to be my baby*
> *Want you to be my baby*
> *Want you to be my baby*
> *Want you to be my baby*
> *Want you to be my ba-byyyyyyyyyyyyyyyyy!*

The beats keep forging on until this ending-offer, at which point a *ritard* enters like the bull in the china shop.

In written music, a symbol called a "fermata" means to sustain a note as long as you like. Doing this kind of ending would be "putting a fermata" on the last note.

 Here's a fermata. On a T-shirt it could be construed as "Hold me." This is my idea. Run with it and risk a lawsuit.

INSERTING A TAG

We looked at one of these in Chapter 5 (you may want to look again). When you create a tag, you're adding a brand new bit of lyric and melody to the ending. It provides an extra, surprise boost, and any singer can toss it into the mix as a song shows signs of imminent conclusion.

This is easy as long as everyone is listening well and accepting offers with ease. Be careful not to interrupt the momentum of any other ending-device already in hot progress.

THE PARTING COMMENT

Any song gets a lift at the very end if an actor speaks a line. It's the cherry on a sundae; the audience isn't expecting it and they're invariably delighted. Doing this will take the energy of their applause up a notch because you gave the musical number a final wink. Examples from performances I've heard:

> *"Take 2 aspirin and call me in the morning."*

> *"Last call? I just got here!"**

> *"I love you baby, honest."*

> *"Don't forget to write!"*

*From the recording of "You and Me and the Bottle Makes Three Tonight (Baby)" by Scotty Morris, on the *Swingers* soundtrack. What a great line.

8

Musical Miracles

Sending your musical improv over the top

THE VOCAL WARM-UP

Get into the habit of doing this. Sing the notes where they feel comfortable (go high or low). Relax, don't strain. Doing a vocal warm-up regularly will improve your range and musical accuracy. Sing along with **CD track 16**.

MAKING GOOD MELODIES

It's common for beginning musical improvisers to sing an entire song within a range of just a few notes. It's understandable; they're trying to do a lot of things at once.

I want you to experiment with creating melodies that contain more variety...skip around from higher to lower notes...remember that you can *hold* a note. Every single line of a song need not be

"brand new;" remember: thematic repetition is good. Listen to **track 17**.

MELODIC EXERCISE

Make up melodies with a repeating catch-phrase for lyrics. On track 17 they use "All I want is a pair of shoes." You can do this by yourself or in a group by taking turns singing a short section. Use **tracks 18-27** for this purpose. The goal of this exercise is to develop your ability to create interesting melodies.

At first you should go a little crazy and just play around. Then challenge yourself to sing simple, consistent tunes that feature thematic repetition. Try singing many different improvised melodies, using the same accompaniment.*

Track 18: *Ballad*

compositional intro / vamp / song starts at 00:21

verse / verse / bridge / verse / last line tripled / ritard at end

Track 19: *Pop*

vamp / song starts at 00:08

verse / verse / chorus / verse / verse / chorus / chorus / ends in tempo, on a button

Track 20: *Blues*

compositional intro / vamp / song starts at 00:18

verse / verse / chorus / verse / verse / chorus / chorus / tag / ritard at end

* When you wish, use these tracks to make up entire songs.

Track 21: *Latin*

compositional intro / vamp / song starts at 00:08

verse / verse / bridge / verse / last 2 lines tripled / "cha-cha-cha" button at end

Track 22: *Country*

vamp / song starts at 00:09

verse / verse / chorus / verse / verse / chorus / last line tripled / ritard at end

Track 23: *Simple Waltz*

compositional intro / vamp / song starts at 00:15

verse / verse / bridge / verse / last 2 lines tripled / ritard at end

Track 24: *Jazz Waltz*

compositional intro / vamp / song starts at 00:15

verse / verse / bridge / verse / last 2 lines tripled / slight ritard at end

Track 25: *Musical Theatre*

compositional intro / vamp / song starts at 00:11

verse / verse / bridge / verse / last 2 lines tripled / ends in tempo

Track 26: *Folk Ballad*

vamp / song starts at 00:07

verse / verse / chorus / verse / chorus / last line tripled / slight ritard at end

Track 27: *Swing*

compositional intro / vamp / song starts at 00:10

verse / verse / 2-line bridge / verse / last line tripled / ends in tempo

WEAVING EXERCISE

Do this with 2 or more actors. Take turns singing a couple of lines each. When it's your turn, begin singing before the last actor is finished.

Actor "A" might hold a final note so that actor "B" can slide in "under it." Listen to the example on **track 28** to hear the singers "weave" vocals together. The goal is to become expert at making a new musical offer before a previous one ends.

Practice this by singing along with **track 29**.

ENDING EXERCISES

You can do these with 1, 2, 3 or 4 actors. Choose any of the 4 parts and stay with it all the way through an exercise.

In a group, it doesn't matter who sings what. The incorporation of harmony into musical improv is a very rough-and-tumble situation.

It is not necessary to memorize these exercises, although you will end up doing that as a result of repetition. Their purpose is to introduce harmonic options to your ears, which you will become able to throw into the mix when you hear melodies and chords similar to those on the CD.

Gradually you will find it easy to sing a nice, functional harmony here-and-there during many a duet, trio, quartet or ensemble number. I call these "ending exercises" because endings of choruses and entire musical numbers are places we especially like to have harmony; however, doing the exercises will improve your ability to harmonize in general.

Just listen and repeat. They are very simple; do them all in a row. The following written music illustrates what you will hear.

Ending Exercise #1
Track 30

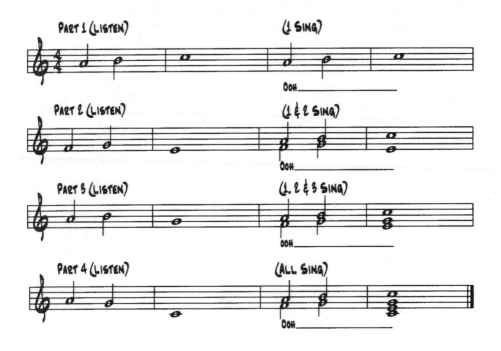

Ending Exercise #2
Track 31

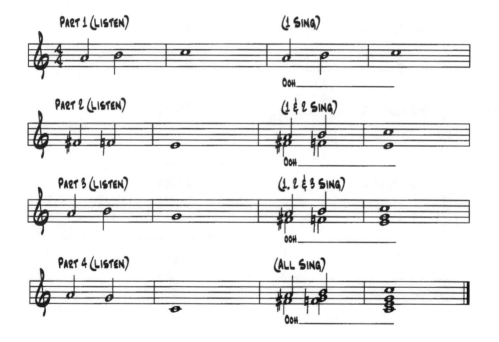

Ending Exercise #3
Track 32

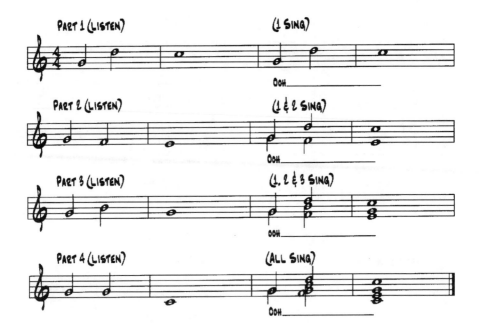

Ending Exercise #4
Track 33

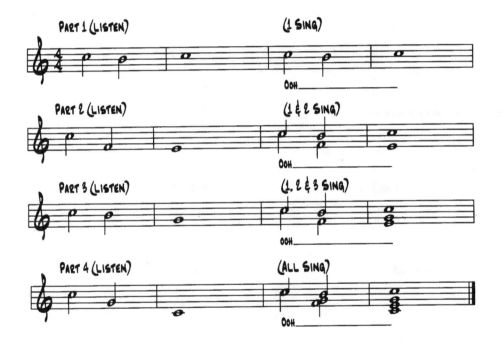

Ending Exercise #5
Track 34

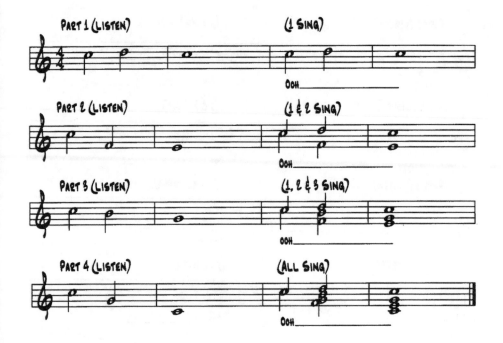

Ending Exercise #6
Track 35

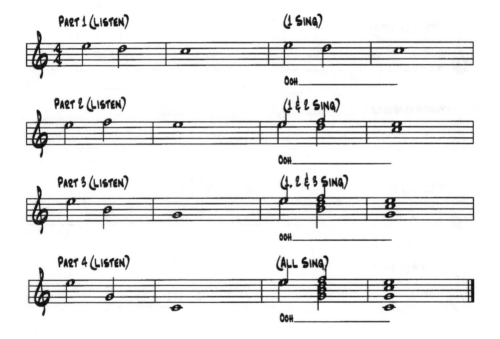

Ending Exercise #7
Track 36

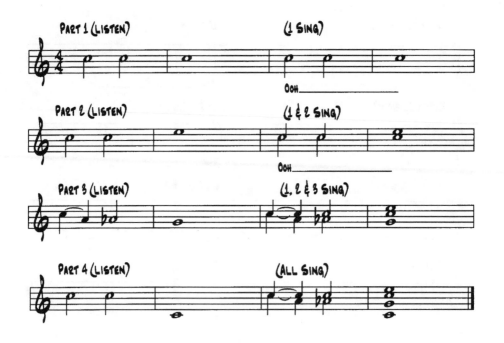

Ending Exercise #8
Track 37

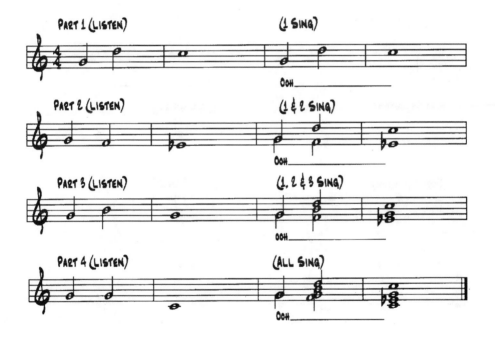

Ending Exercise #9
Track 38

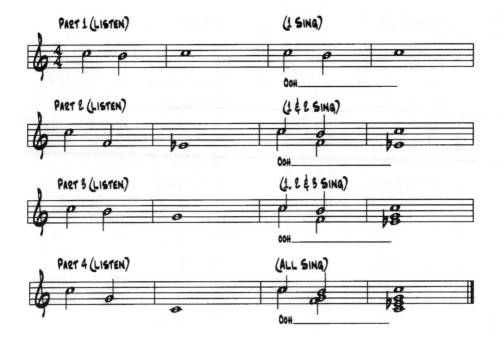

Ending Exercise #10
Track 39

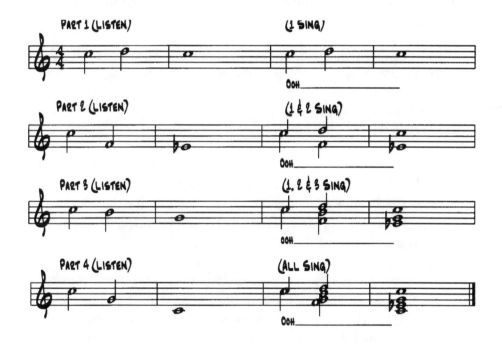

"WE ARE THE WORLD" EXERCISE

Do this with 2 or more actors. I call it "We Are the World-ing" because the echoing backup vocals in that hit song are such a familiar reference for most people.

This is a great way to sing supportively with someone else's solo; it can take the form of strict "echoing" of a line just sung, or creative commentary of different kinds. Listen to the example on **track 40**.

Practice doing this with the accompaniments on **tracks 18-27, 29 or 42.** You can "We Are the World" in any style.

MIRRORING EXERCISE

This is a well-known technique for duets. It can serve a section or the last few lines of any song, provided that the melody/lyrics move slowly enough to accomplish the "trick." It's the vocal version of 2 actors mirroring each others' movements, as if one person is a reflection of the other.

One actor follows the lyric and melody sung by another, copying it exactly. For an ending, try harmonizing as well. Look at each other, listen closely and let one person take the lead. Audiences find this delightful, and of course they laugh even more when you mess up.

Practice by singing short, entire songs together, mirroring the whole time. As you know, lyrics/melody can move languidly across *any* accompaniment, so once again, **tracks 18-27, 29 or 42** will work fine.

COUNTERPOINT

Counterpoint is the sound of 2 or more contrasting melodies happening at the same time. (Tip: Sound like a genius by referring to these melodies as "contrapuntal.")

Below is the basic formula for 3-part counterpoint in musical improv. Do not be intimidated. This is ridiculously easy, and the results are spectacular.

	1	*2*	*3*
RHYTHM	Busy	Sustained	Sparse
MELODY	Complex	Soaring	Simple

Listen to the example on **track 41**:

a. *Busy/complex* section begins.

b. *Sustained/soaring* joins in.

c. *Sparse/simple* enters the picture.

d. The sustained/soaring singer (easiest for everyone else to hear and duplicate) makes an ending offer and we wrap it up.

This technique lends itself particularly well to opera and musical theatre. If you want to add a 4^{th} part, make it one of the sustained/soaring variety.

Practice different parts by yourself or in a group with **track 42**.

TIPS REGARDING VARIOUS NUMBERS OF SINGERS

The Solo

You have a lot of freedom here! Beginners tend to believe that they're in far more danger of singing something "wrong" than they actually are. Your accompanist is out to have fun playing with you, not to be the Music Police.

Seasoned improvisers will grab onto a musical offer and lead the way....slowing down, speeding up, stopping, coming back in, talking and creating multiple tags that build an ending like a wedding cake. These things are easiest to do when you have only to be in good communication with your accompanist, not share vocals with other actors.

You can hardly practice that kind of abandon with recorded accompaniment, so use the tools I've presented to become expert at the basics. When you have live accompaniment, rehearse in an adventurous way and take advantage of the great things you can get away with when you sing by yourself.

Duets, Trios and Quartets

A good way to begin creating songs with multiple actors is to share in a very structured approach.

Co-create basic song forms by taking turns singing lines, in sequence. Vary this by trading off every 2 lines, or every verse. If you want to include a chorus, one person would make that offer (as in Chapter 5).

You should become fluent with any version of taking turns in an organized way. Ultimately you want to cooperate freely, singing portions of a song in no particular order by trading offers.

I recommend alternating frequently between a structured and a "freestyle" approach with 2, 3 and 4 singers. "Freestyling" is easier in some ways, harder in others (when you can sing at any time you like, it becomes challenging to trade offers smoothly).

The main thing is to always maintain good overall musical form. This is pretty easy when everyone is at a similarly high level of ability. In a situation involving beginners and non-beginners, the more skilled improvisers can provide as much influence as needed to keep things together.

Multiple singers must, of course, take good care of each other. Set up easy rhymes for others to latch onto; sing verse and chorus melodies that are easy to replicate.

Lyrically, make sure that a relationship between the singers is evident. Things become 100% more interesting right away when you're mutually involved. Are you lovers? Are you co-workers? Family members? Sing to each other and let us know who you are and how you feel about each other. Do you generally agree or disagree during this song?

Listen to **track 43**. This is an example of 4 singers trading lines in an entire song.

Practice with **tracks 18-27**.

Five and Six Singers

Six actors are as many as you're likely to want in an improvised song. Beyond that is quite a crowd—it becomes difficult to effectively exchange offers. In this section I'm talking about the kind of group song that might occur in an improvised musical.

Here's a typical sequence of events:

> *One actor starts it off with a solo, followed by a few more actors singing short solos. Soon we hear the offer of a simple phrase or two that can be repeated by others. (This could be a straightforward chorus, or more of a sung "chant." Let's say it's a chant.)*

> *As a chant catches on, spreading like wildfire through the group, individual creativity abounds—actors echoing each other and playing with melody in simple ways.*

> *Next, someone influences the group to sustain a word/note all together, and set up the emergence of a new solo. The song moves on, applying all the principles of musical improv that would work with 2-4 singers…trading lines— offers and acceptances.*

> *The song goes back to the chant. After that goes on for awhile, a clear ending-offer appears, to lead us home.*

Listen to the example of an ensemble number on **track 44**. It's only 4 singers, but it works the same way it would with 5 or 6.

A large group number will be inclined to depart from basic song forms and grow into its own, beautiful, metamorphosed thing. Together with the accompanist, each singer helps create and maintain an appealing shape for the entire song.

Practice with **track 45**. It won't be the same as live accompaniment because it can't develop according to your offers, as it ideally would. Nevertheless, this track will work okay.

9

May We Have a Style Please?

Becoming an expert at musical styles and genres

A style is a distinctive form of expression. A genre is a broad category containing many styles. For example, if the musical genre is "jazz," there are a number of ways we could go (dixieland, contemporary...). This is good—we have options. When you request the suggestion of a style from the audience, they often come up with a genre instead.

In that case, we select a style to fill the bill, and it should be a very typical, definitive representation of the genre. Ask, "What do *most* people think of as jazz?" We're creating a caricature; a cartoon. Whatever we do, it's not going to be subtle. We want to include and exaggerate the things that are unmistakably jazzlike. Some jazz styles have too much in common with other genres to be our best choice. We don't want our jazz song to sound anything like rock, for example.

The playing field narrows when the audience suggests an actual, specific style. "Musical Theatre" is one thing, "Sondheim" is quite another.

Let's say you have a selection of bells in front of you, each of which is an element of a particular style. The more of these you manage to ring, the higher your score with the judges. The way to acquire the right bells follows.

THE PERFORMANCE ELEMENTS OF MUSICAL STYLE

Remember them with this handy mnemonic phrase:

Peter Rabbit Visits Little Mermaid In Hawaii

1. Physical

How does the singer stand, move, pose, gesticulate and express him/herself facially in the suggested style? What kind of attitude is involved? Assume an appropriate physicality and the audience can begin to appreciate your stylistic treatment even before you sing. This is very powerful and interesting.

2. Rhythmic

Being the most basic element of music, rhythm will influence everything you do to spotlight a style. How should a song in this style flow, what is its rhythmic personality? You don't have to get too technical about it—just listen to music and notice how it feels, how your body tends to move in response. Begin to associate that with the style you're examining. Compare and contrast everything you hear from a rhythmic point of view. Define it: hard driving, lazy, funky, peppy, foot-stompin', and so on.

3. Vocal
Take on a vocal quality that makes sense for the style. Assume the accent, the brand of enunciation (is it precise or is it sloppy?). What famous person would sing in this style? Try "impersonating" them. If you're not perfect, that's good. The audience won't know who it is. Improvising in a musical style is acting a role, and vocal characterization is a great way to enhance both the song and the comedy.

4. Lyrical
Notice the sort of language that prevails in a particular style. The lyrical nature of a musical style is a combination of linguistic origin and level of sophistication. When you hear an example of a style, remember to observe the words and look for distinguishing details. Create a description—Grandma's love song, beatnik prose, stoned musings, street talk, Mississippi front porch, big city seduction—whatever rings true for you.

5. Melodic
This is the tune! Is it simple, sweet and innocent like a children's song? It may be bluesy, sleazy, prayerful, zingy, soaring, weird...find ways of describing melodies through your own musical perspective. For example, I think of Zydeco as "French hoedown." This presents a musical image that's easy for me to remember.

6. Instrumental
When a style is heavily associated with the sound of an instrument, we say that the style is "driven" by that sound. Ragtime is piano-driven; Hard Rock is drums-driven. You might say that New Age music is "synthesis-driven." It employs a lot of spacey, synthetic sounds.

The way you're accompanied is naturally going to have a big influence on your performance of a style. Usually a keyboardist has the responsibility of making the very first musical offer involved.

You may only have the sound of a piano, which is versatile but not perfect for every style. Your accompanist can be creative with whatever machinery is practical, and contribute to the objective at hand. If the sound of a particularly appropriate instrument is available, great! If not, that's okay because we'll compensate with other stylistic elements.

If someone in your company can improvise on guitar or harmonica, utilize them when needed. Shakers and tambourines come in handy for an actor to pick up and support a style.

We're not out to do a lifelike portrait, but a caricature, remember? We paint with broad strokes. Audience imagination plays its part, and they get the picture.

7. Harmonic
Harmony is the sound of more than one note heard together. There are some cool harmonic things you can improvise vocally (see Chapter 8).

Here, I'm principally referring to the harmonic aspect of your accompaniment—chords and chord progressions typical of particular styles. I hope you have the opportunity to spend time with your keyboardist and explore this. It's interesting how the same melody can be treated in different harmonic ways. For an example of this, listen to **track 46**.

Even if you're not a musician, you can observe the sorts of chords that accompany different kinds of music and describe them. Useful words: cheery, dark, edgy, lush, harsh, angelic, spare, bizarre, complex, homegrown, sophisticated. Harmony is aural color, and "colorful" descriptions like these will go a long way in communicating with an accompanist.

By the way, a spectacular tool for keyboard players is *The Contemporary Keyboardist*™ *Stylistic Etudes* by John Novello.

∽

According to your personal taste and background, some styles will be quite easy to do. Select one that's a piece of cake, and analyze it per the 7 elements shown above. You may unearth a new detail or two that you can use in the future.

When you look at the components of a brand new style, discuss and bring them into rehearsal. Once you've gotten up and tried putting them together a few times, the separate elements will fuse together into an impression that is easy to recall.

Here's a list of styles and genres I've heard audiences suggest. You can probably think of more.

Acid Jazz	Jazz
Alternative	Klesmer
Andrew Lloyd Webber	Las Vegas
Barbershop Quartet	Latin
Big Band	Lounge
Blues	Mariachi
Bossa Nova	Motown
Boy Band	Musical Comedy
Broadway Musical	Musical Theatre
Bubble Gum	New Age
Burlesque	New Wave
Calypso	Opera
Children's Song	Polka
Christian Rock	Pop
Classic Rock	Pop Opera
Classical	Pop Diva
Country	Punk Rock
Disco	Ragtime
Disney	R & B (Rhythm and Blues)
Dixieland	Rap
Doo-Wop	Reggae
Easy Listening	Rock
Fifties Rock	Rock Opera
Folk	Rock & Roll
Gilbert & Sullivan	Rodgers and Hammerstein
Glam Rock	Salsa
Gospel	Stephen Sondheim
Gregorian Chant	Soul
Grunge Rock	Square Dance
Hard Rock	Swing
Hawaiian	Torch Song
Heavy Metal	TV Theme
Hip Hop	Zydeco

Audiences also like to name artists: Beatles, Sinatra, Queen, Britney Spears, Elvis, et al. No doubt about it, style games demand a lot of knowledge that we'll all continue to build upon forever. Fortunately, it's fun.

Start a looseleaf workbook containing one style per page, with your personal notes concerning all 7 seven performance elements of a musical style. Call upon your friends' musical tastes and knowledge; discuss styles and genres; borrow their CDs. See what recordings are available at your public library—probably a wealth of material you'd never buy, but you can hear it for free.

You now have the tools to work with musical styles and genres like a pro. The 7 puzzle pieces are constant; only their labels change.

10

Ladies and Gentlemen, It's Showtime

A collection of musical improv games

1. Make-A-Song

No surprises here. One or more players create a song, based on any kind of suggestion from the audience. When 3 or 4 players are involved, some call this "Jam."

2. Lounge Singer

"What's an unusual place to find a lounge singer?" A player assumes the role of an entertainer who appears nightly in an odd environment, suggested by the audience...a gas station, elevator, mortuary, etc.*

*This game was originated by Jeff Davis when we were in a group called The Impromptones.

3. Torch Song

"What's something people say when they break up?" Get any kind of audience suggestion you like...it doesn't need to be about love; however, a girl singer takes the suggestion and creates a sexy, romantic ballad a la "Can't Help Lovin' That Man of Mine." A torch song is a bluesy, pulsing lament about the trials of love, as in "carrying a torch" for someone.

4. Musical Comedy

This is a mini-musical. Actors create a scene and burst into song regularly. You can have as many songs as you want, but I suggest 3: boy meets girl (song), boy loses girl (song), boy gets girl (song). Make sure each musical number has a definite ending, so that the audience gets to applaud several times during the game. Anything can happen; go for a happy finale.

5. Song Option

Actors create a scene and an emcee freezes the action from time to time, quoting the last line spoken ("Baby, you don't have a clue"), which becomes a song. The actor who said the line should carry the song, while the others lend support and focus.

a. You can play this game using just the quoted lines to create songs, or

b. the emcee can also gather a collection of musical styles from the audience at the beginning, and assign a style to each song just before it is sung. Obviously, this is more challenging. The emcee can help ensure success by *choosing* styles that the actors can work with easily.

6. Initials

1-4 actors sing a song in which an audience member's initials figure prominently, as often as possible. Here's an example using my initials, MP:

> *Most People* never find love like this
> *My Papa* told me so
> You're *More Perfect* than *Mary Poppins*
> A *Magnificent Person,* you know...

7. Opera

An audience suggestion prompts the actors to create a scene that is entirely sung. Listen to the example on **track 47**.

8. Words From the Hat

Prior to a show, get audience members to write single words on index cards. Put them in a hat or any likely container. Two or more actors create a single song by taking turns (frequently) drawing index cards and making up lyrics based on the resultant, crazy collection of words. Provide bold markers for the audience to write the words and hold up each card for all to see as you perform the song.

9. Musical Chairs

Here's another "hat" game. This is best played by 4-6 actors. The emcee gathers suggestions of musical styles from the audience and writes each one on a slip of paper—they go into a container. Next, the actors play the kids' game, musical chairs, and the audience laughs as they act silly, circling around a group of chairs (6

actors, 5 chairs) to music. When the music stops, someone is left standing. This actor must draw a style "from the hat."

At that point, the actor asks for the suggestion of a made-up song title, and performs a song based on the title and in the appointed style. When the song is over, he/she is out of the game. We subtract a chair and play musical-chairs again.

The game ends when the last actor in the group (who actually "won" musical chairs) presents a final song.

10. Competition Rap

This is a good game for 4-6 actors. Get an audience member's one-syllable name and trade lines one-by-one until someone runs dry.

> *Well I know a guy whose name is **Tim***
> *He don't eat much, he's really **slim***
> *Every day he goes to the **gym***
> *Lots of girls are in love with **him***
> *Especially a blonde by the name of **Kim***
> *She ain't smart, she's kinda **dim***
> *However, she has a wonderful figure and comes from money...* *

The audience laughs and an actor is eliminated.

*When you have nothing, mess up BIG. We play this game in the show at Disney's California Adventure, and the actors get huge laughs when they go off on lengthy tangents that don't rhyme at all.

The game starts again with a new audience-member name, and the remaining actors battle it out. We laud the champion at the end.

～

I'm sure you can think of many more possibilities; these cover a lot of ground and should keep you busy for awhile.

11

Putting on the Brakes

This book is almost over

Who could forget the vivid "choo-choo train" analogy about endings in Chapter 7? As you read this, imagine just the slightest jolt in your ride—enough to disturb but not spill your coffee.

The scenery passes more slowly as we head away from the plains of the unknown and right into a small town—only a speck of pepper on the map, really. It's populated by people who know what the hell they're doing in musical improv games. Wave to Wayne Brady, even though it's just his picture on a billboard.

Welcome, pilgrim, you made it. We're not at the station yet but it's in sight, and won't it be great to get out and play?

Well, it might be and it might not. Even when you're soloing, this is a team thing because you'll likely have someone accompanying

you. As in any game, it's most fun when everyone understands how best to play. It's now your responsibility to purchase this book for everyone with whom you wish to improvise songs.

Okay, I'm kidding.* The thing to do is share what you've learned. Some people understand intuitively "how songs go," no matter what kind. Others need guidance in certain areas—perhaps in creating an ending to a song. You can help, so go to it.

Onstage, assertive offers from you can steer everyone to triumph. They may not even know how it happened. An actor who leads the way with good musical sense is a delight for everyone—the piano player, other actors, and of course the audience.

This train is crawling to a halt now. Gather up your things and turn the page.

*No I'm not.

Last Thoughts

I wrote this because I needed a text for my classes and workshops. Instead of continuing to duplicate hand-outs and cassettes to serve as study material, I decided to organize the information and create a book.

I asked my brilliant friends for help—Christopher Colley to assist me in technical and creative ways, Michael Sherman to do artwork and layout, Sonja Alarr to be my editor and Jason Alexander to write a foreword. It all worked out, and here's the product. I hope you've enjoyed and found it valuable.

Many thanks to the cast members from *Opening Night: The Improvised Musical*, who appear on the CD: Shulie Cowen, creator and director of the show, along with Sami Klein, Norm Thoeming and Jack Voorhies. They are among the very funniest and finest.

Special thanks also to my friends Howard Richman and Kit Winter for their expert advice and support.

I'm grateful to my students, who ask questions that frequently lead me to learn more about musical improv. My work with Off the Wall, The Comedy Store Players, ComedySportz LA, The Impromptones, The Newtonics, ImprovOlympic West and The Second City Los Angeles represents hundreds of rehearsals and performances. I've done my best to bring you the results of my experience in relatively few words.

Thanks,

Michael

Carol's Theme

I'm so glad we had this time together
Just to have a laugh and sing a song
Seems we just get started, and before you know it
Comes the time we have to say "So long."

INDEX (page numbers to come)

A song ain't nothin' in the world but a
story just wrote with music to it.

Hank Williams